MAGRITTE

This is not a biography

Written by

Vincent Zabus

Art and Colours by

Thomas Campi

SELF MADE HERO

Thanks to Thomas and his talent for endless reinvention.
Thanks to Nathalie, Camille and Gauthier for their trust and
their work.
VINCENT

I'd like to thank Nathalie, Camille and Vincent for their patience
and support. Thanks to René Magritte and his ironic art for
inspiring me and making me dream. Thanks to all the ways art
has contributed to making me a better person.
THOMAS

First published in English in 2017
by SelfMadeHero
139-141 Pancras Road
London NW1 1UN
www.selfmadehero.com

Written by Vincent Zabus
Illustrated by Thomas Campi
Translated from French by Edward Gauvin

Publishing Director: Emma Hayley
Sales & Marketing Manager: Sam Humphrey
Editorial & Production Manager: Guillaume Rater
UK Publicist: Paul Smith
US Publicist: Maya Bradford
Designer: Txabi Jones
With thanks to: Dan Lockwood

A CIP record for this book is available from the British Library

ISBN: 978-1-910593-37-0

10 9 8 7 6 5 4 3 2 1

Printed and bound in Slovenia

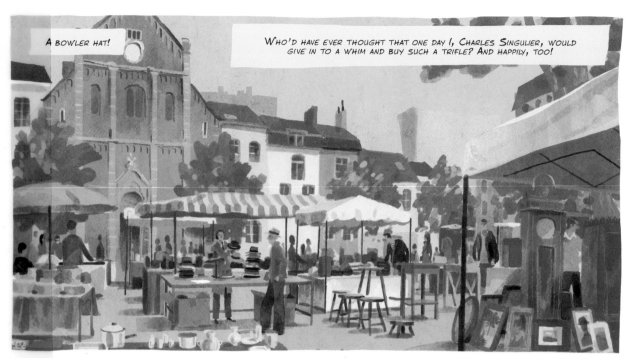

A BOWLER HAT!

WHO'D HAVE EVER THOUGHT THAT ONE DAY I, CHARLES SINGULIER, WOULD GIVE IN TO A WHIM AND BUY SUCH A TRIFLE? AND HAPPILY, TOO!

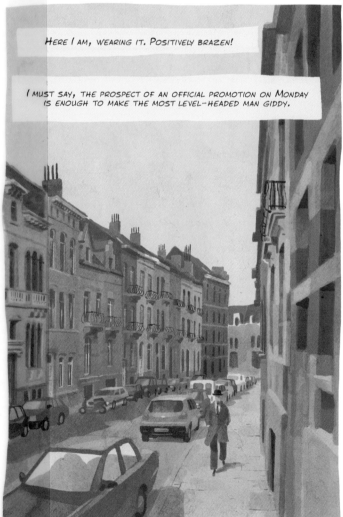

HERE I AM, WEARING IT. POSITIVELY BRAZEN!

I MUST SAY, THE PROSPECT OF AN OFFICIAL PROMOTION ON MONDAY IS ENOUGH TO MAKE THE MOST LEVEL-HEADED MAN GIDDY.

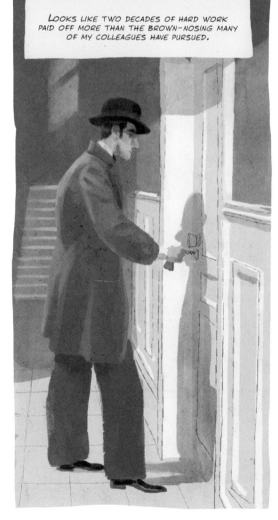

LOOKS LIKE TWO DECADES OF HARD WORK PAID OFF MORE THAN THE BROWN-NOSING MANY OF MY COLLEAGUES HAVE PURSUED.

LUNCHTIME. TWENTY-FOUR HOURS FROM NOW, I'LL BE A NEW MAN!

?!

!!!

I...

I'D BETTER COLLECT MY WITS.

HIGH TIME I TOOK OFF THIS DAMNED HAT.

?

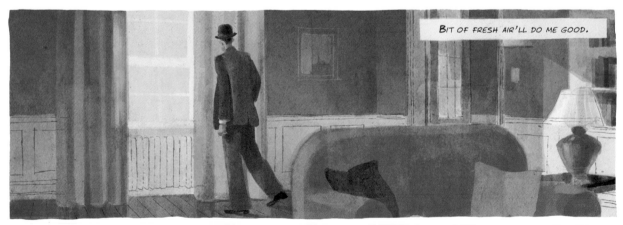

BIT OF FRESH AIR'LL DO ME GOOD.

4

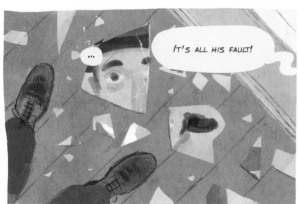

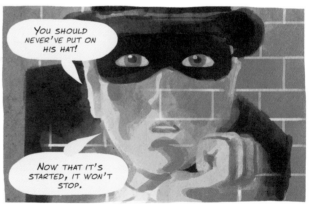

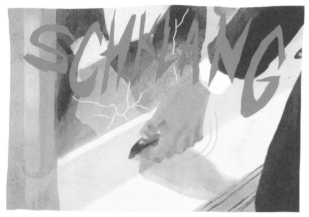

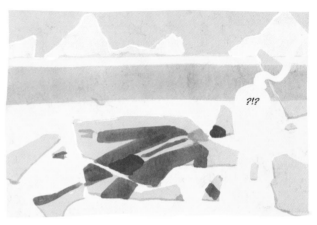

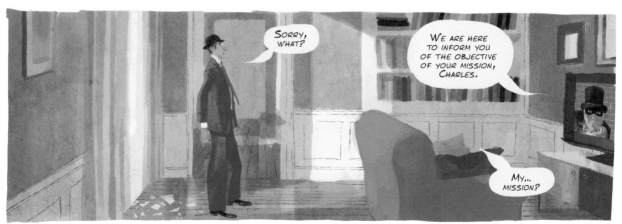

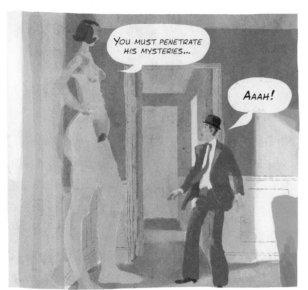

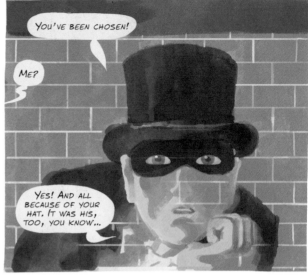

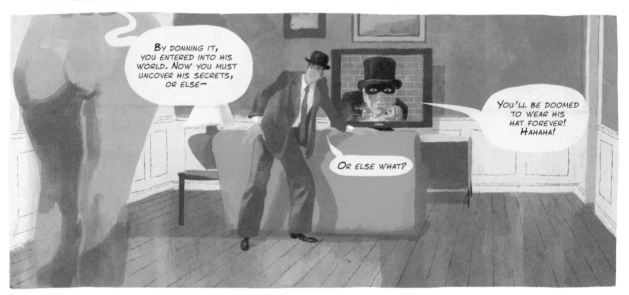

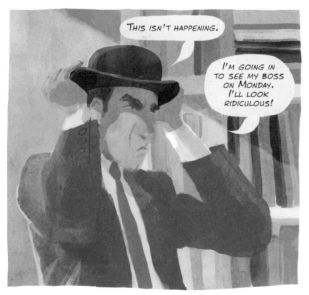

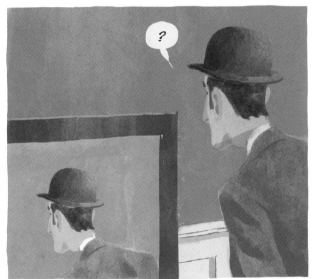

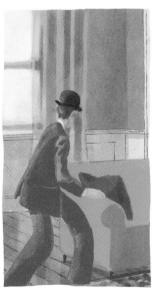

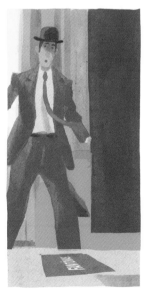

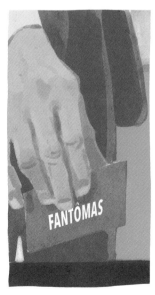

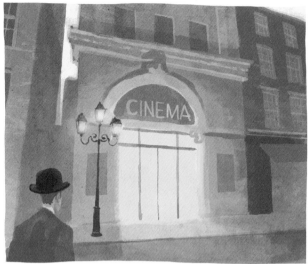

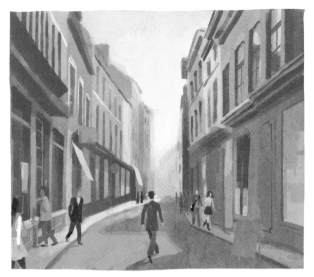

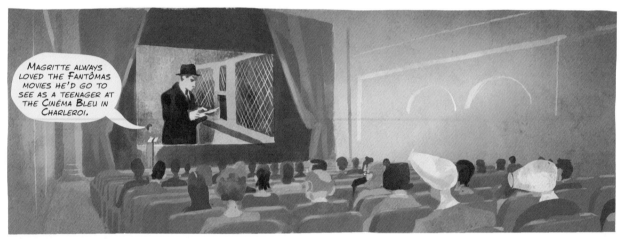

MAGRITTE ALWAYS LOVED THE *FANTÔMAS* MOVIES HE'D GO TO SEE AS A TEENAGER AT THE *CINÉMA BLEU* IN CHARLEROI.

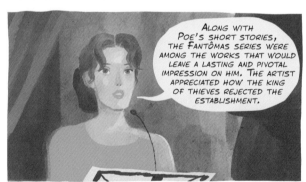

ALONG WITH POE'S SHORT STORIES, THE *FANTÔMAS* SERIES WERE AMONG THE WORKS THAT WOULD LEAVE A LASTING AND PIVOTAL IMPRESSION ON HIM. THE ARTIST APPRECIATED HOW THE KING OF THIEVES REJECTED THE ESTABLISHMENT.

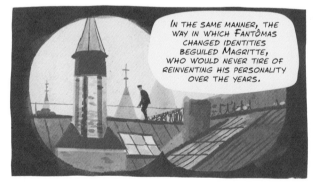

IN THE SAME MANNER, THE WAY IN WHICH *FANTÔMAS* CHANGED IDENTITIES BEGUILED MAGRITTE, WHO WOULD NEVER TIRE OF REINVENTING HIS PERSONALITY OVER THE YEARS.

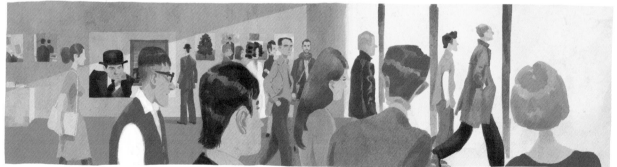

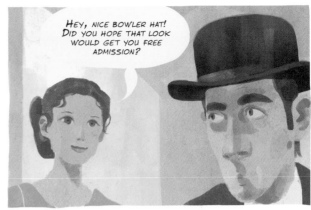

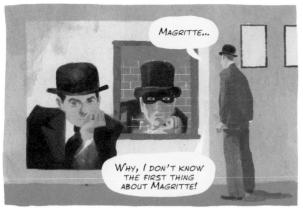

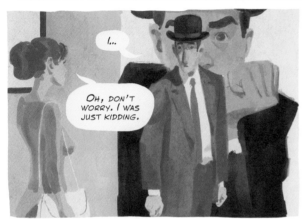

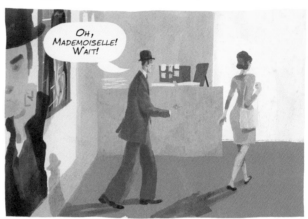

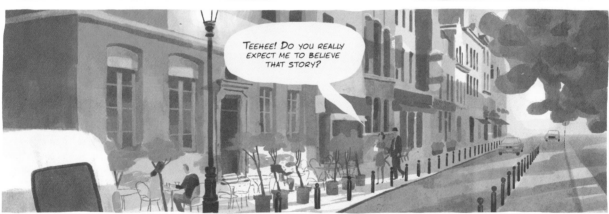

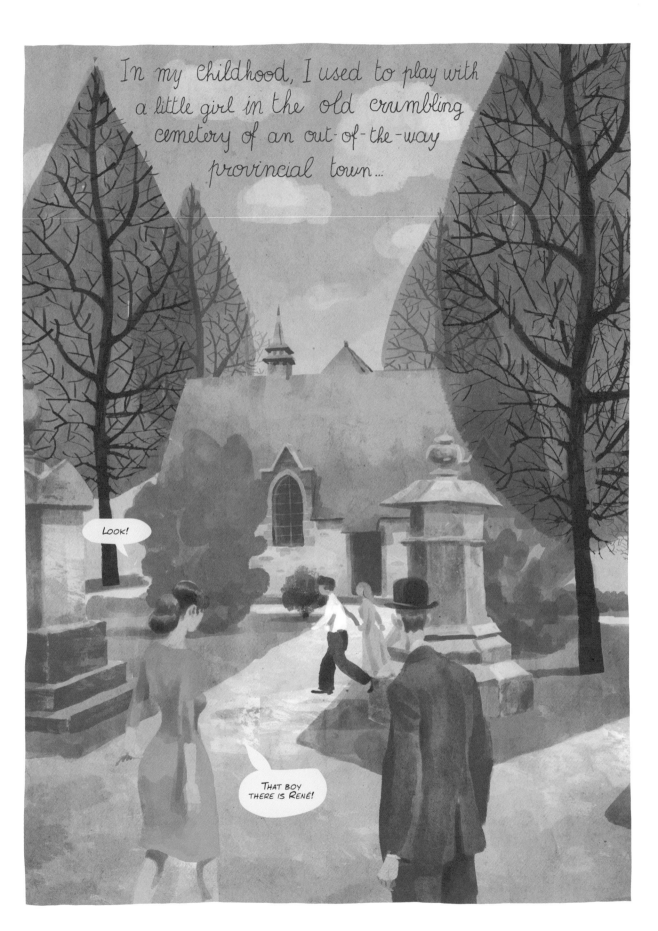

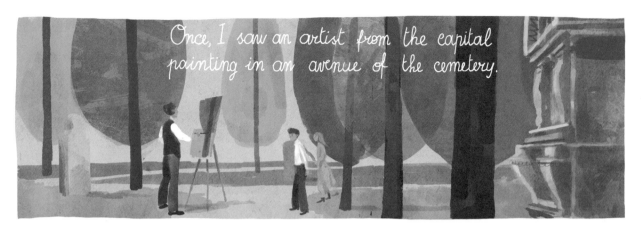

Once, I saw an artist from the capital painting in an avenue of the cemetery.

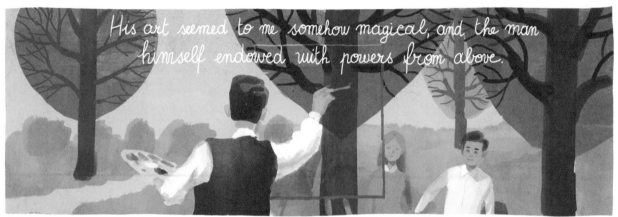

His art seemed to me somehow magical, and the man himself endowed with powers from above.

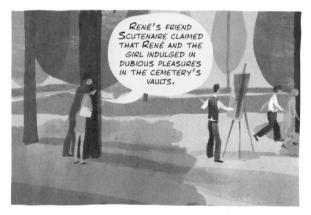

René's friend Scutenaire claimed that René and the girl indulged in dubious pleasures in the cemetery's vaults.

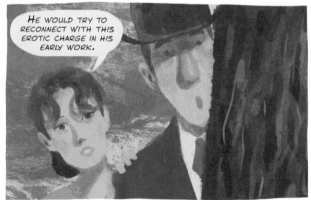

He would try to reconnect with this erotic charge in his early work.

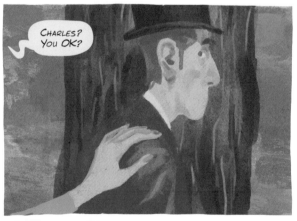

Charles? You OK?

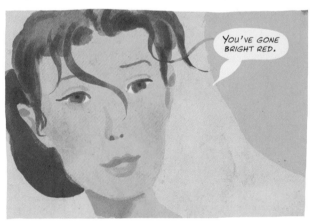

You've gone bright red.

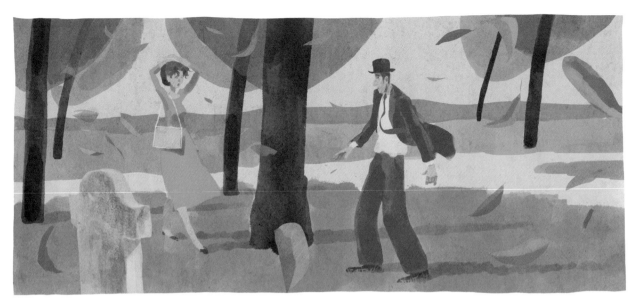

AAAH!

FLEE...

FLEE, WHILE YOU STILL CAN!

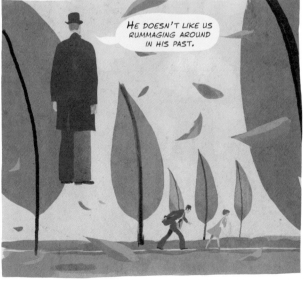

HE DOESN'T LIKE US RUMMAGING AROUND IN HIS PAST.

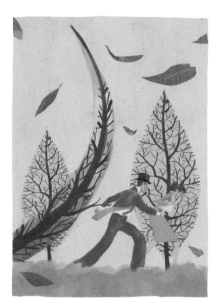

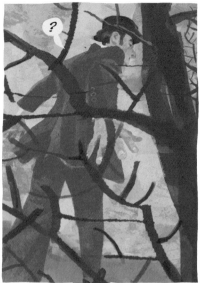

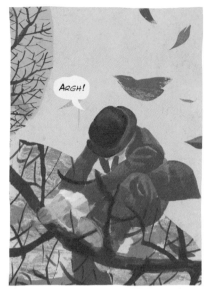

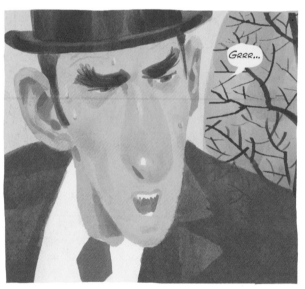

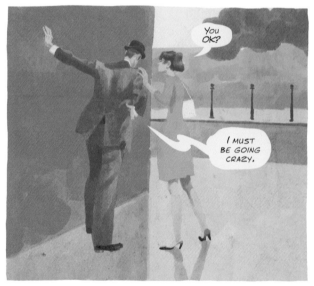

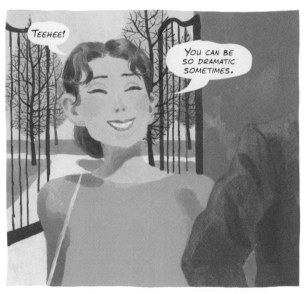

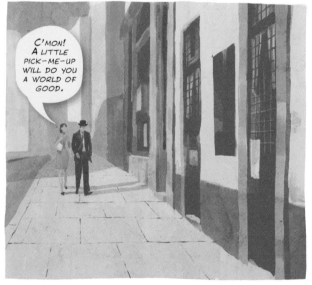

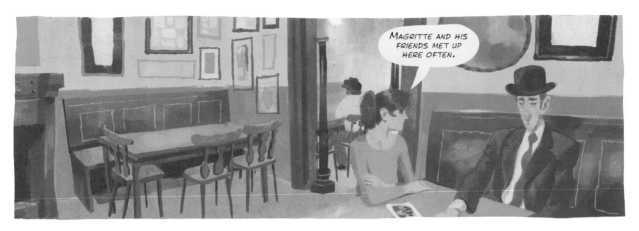

MAGRITTE AND HIS FRIENDS MET UP HERE OFTEN.

No one is as much a stranger to me as myself

THE WALLS STILL BEAR TRACES OF THEIR JOLLY ANTICS.

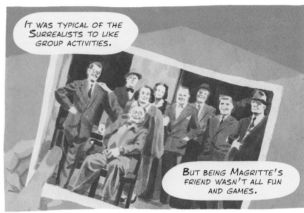

IT WAS TYPICAL OF THE SURREALISTS TO LIKE GROUP ACTIVITIES.

BUT BEING MAGRITTE'S FRIEND WASN'T ALL FUN AND GAMES.

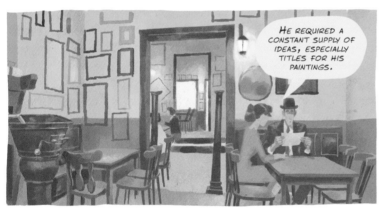

HE REQUIRED A CONSTANT SUPPLY OF IDEAS, ESPECIALLY TITLES FOR HIS PAINTINGS.

AS MY ART PROFESSOR SAID: "TITLES IN MAGRITTE ARE THERE TO PREVENT HIS WORK FROM BEING PERCEIVED IN A REALIST FASHION."

MAGRITTE AND HIS PALS MADE FILMS, WENT ON HOLIDAY TOGETHER... AND YET HE WAS A LONELY, MELANCHOLY SOUL. ONE OF HIS MANY PARADOXES!

?!

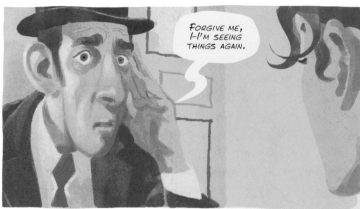

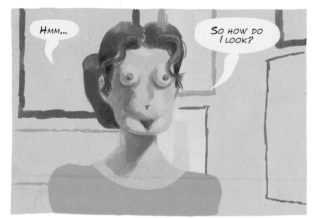

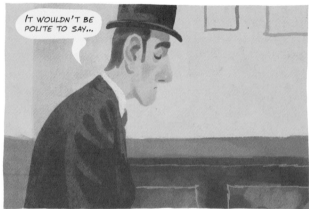

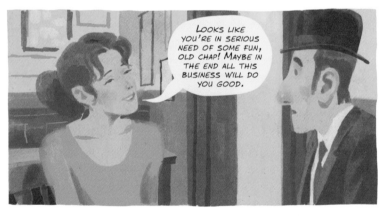

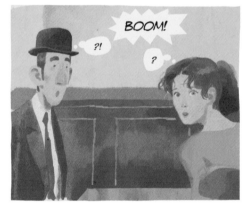

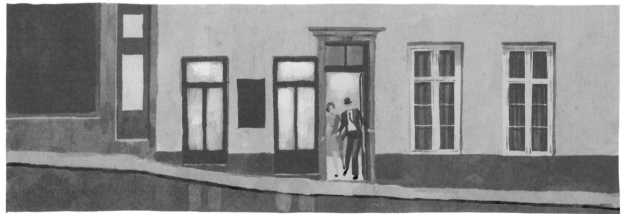

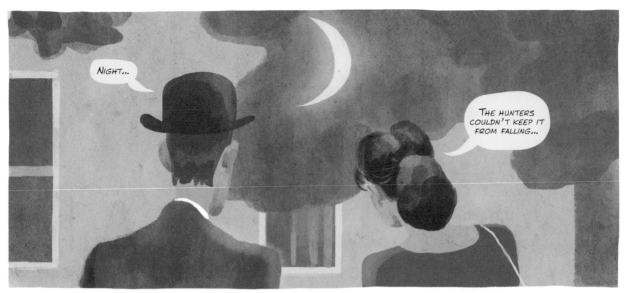

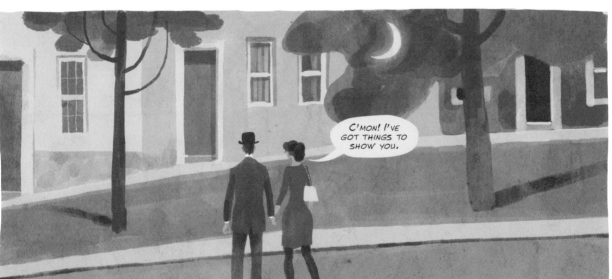

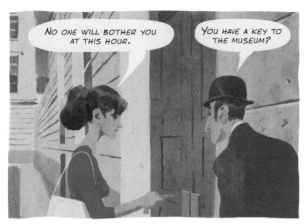

NO ONE WILL BOTHER YOU AT THIS HOUR.

YOU HAVE A KEY TO THE MUSEUM?

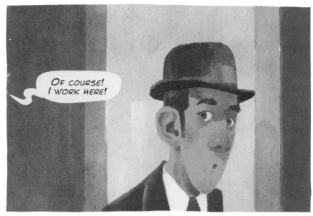

OF COURSE! I WORK HERE!

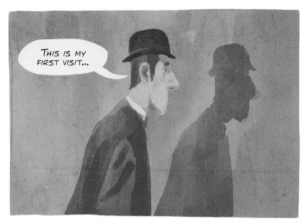

THIS IS MY FIRST VISIT...

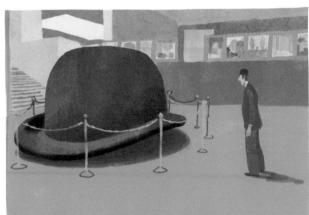

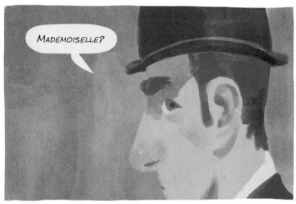

MADEMOISELLE?

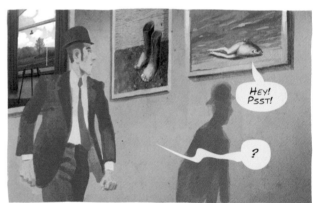

HEY! PSST!

?

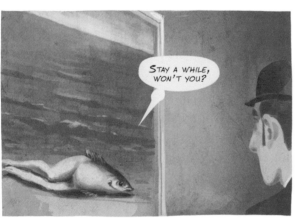

STAY A WHILE, WON'T YOU?

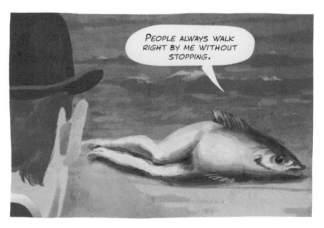

PEOPLE ALWAYS WALK RIGHT BY ME WITHOUT STOPPING.

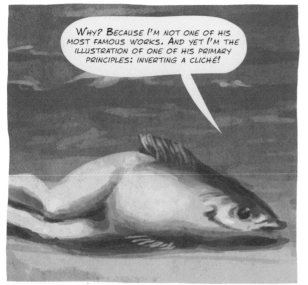

WHY? BECAUSE I'M NOT ONE OF HIS MOST FAMOUS WORKS. AND YET I'M THE ILLUSTRATION OF ONE OF HIS PRIMARY PRINCIPLES: INVERTING A CLICHÉ!

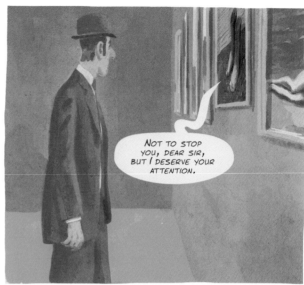

NOT TO STOP YOU, DEAR SIR, BUT I DESERVE YOUR ATTENTION.

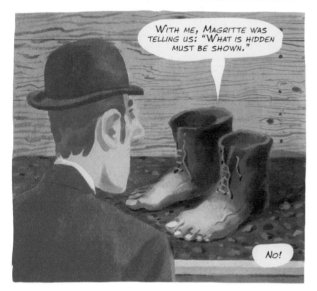

WITH ME, MAGRITTE WAS TELLING US: "WHAT IS HIDDEN MUST BE SHOWN."

NO!

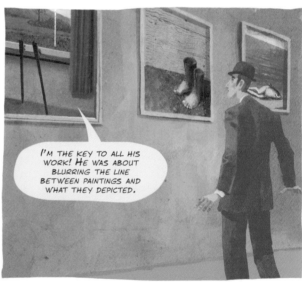

I'M THE KEY TO ALL HIS WORK! HE WAS ABOUT BLURRING THE LINE BETWEEN PAINTINGS AND WHAT THEY DEPICTED.

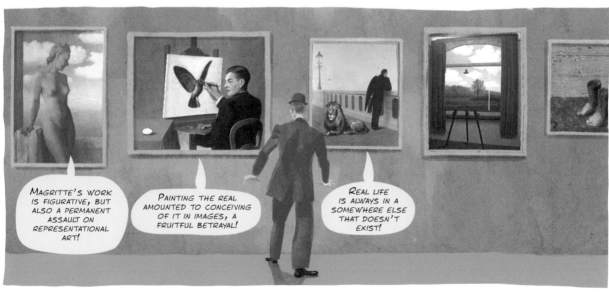

MAGRITTE'S WORK IS FIGURATIVE, BUT ALSO A PERMANENT ASSAULT ON REPRESENTATIONAL ART!

PAINTING THE REAL AMOUNTED TO CONCEIVING OF IT IN IMAGES, A FRUITFUL BETRAYAL!

REAL LIFE IS ALWAYS IN A SOMEWHERE ELSE THAT DOESN'T EXIST!

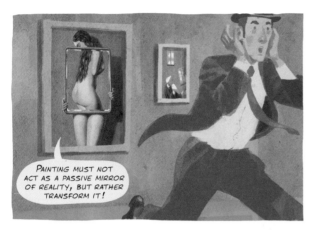

PAINTING MUST NOT ACT AS A PASSIVE MIRROR OF REALITY, BUT RATHER TRANSFORM IT!

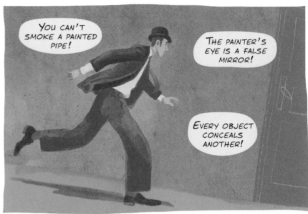

YOU CAN'T SMOKE A PAINTED PIPE!

THE PAINTER'S EYE IS A FALSE MIRROR!

EVERY OBJECT CONCEALS ANOTHER!

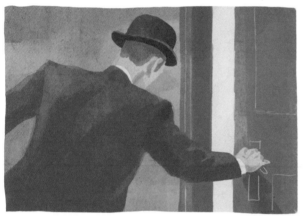

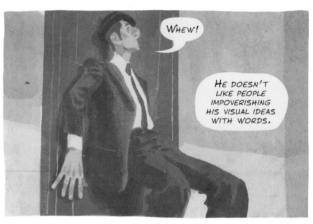

WHEW!

HE DOESN'T LIKE PEOPLE IMPOVERISHING HIS VISUAL IDEAS WITH WORDS.

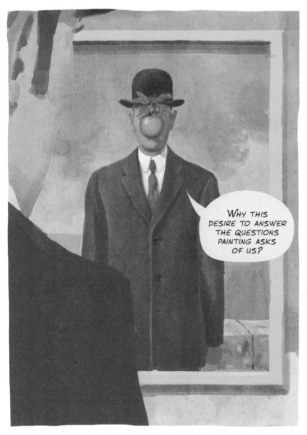

WHY THIS DESIRE TO ANSWER THE QUESTIONS PAINTING ASKS OF US?

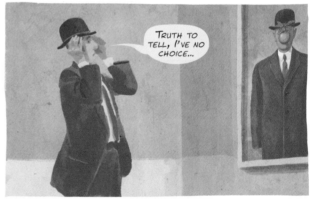

TRUTH TO TELL, I'VE NO CHOICE...

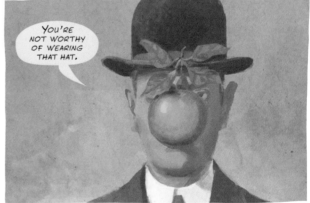

YOU'RE NOT WORTHY OF WEARING THAT HAT.

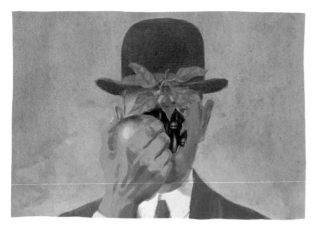
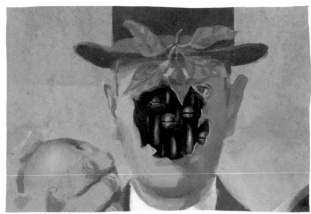
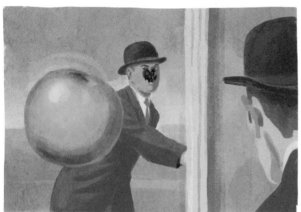
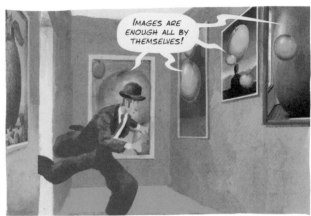

IMAGES ARE ENOUGH ALL BY THEMSELVES!

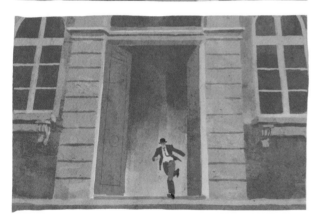
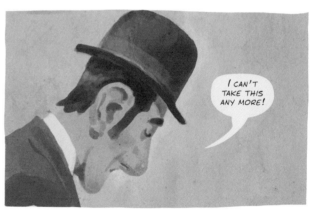

I CAN'T TAKE THIS ANY MORE!

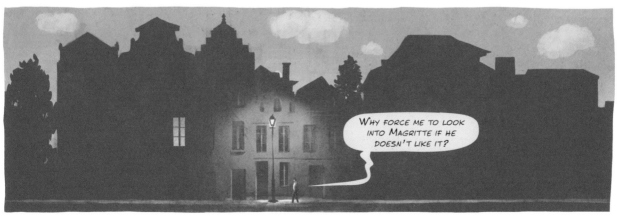

WHY FORCE ME TO LOOK INTO MAGRITTE IF HE DOESN'T LIKE IT?

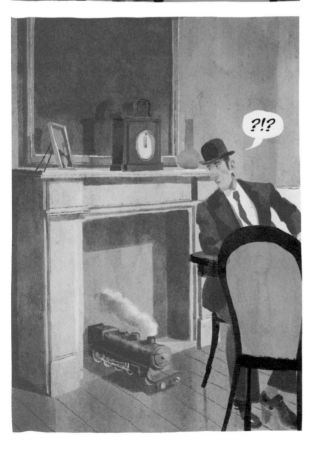

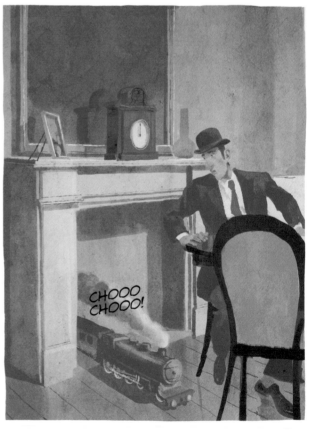

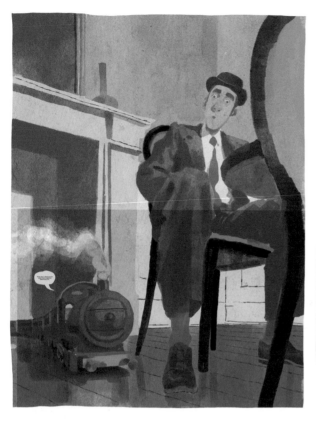
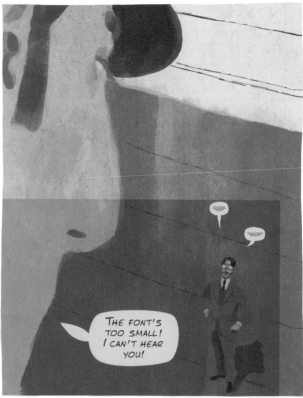

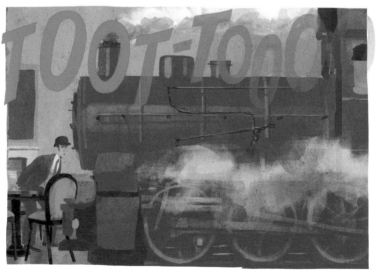
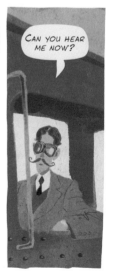

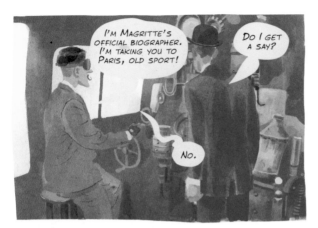

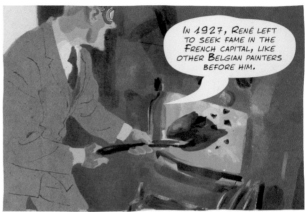

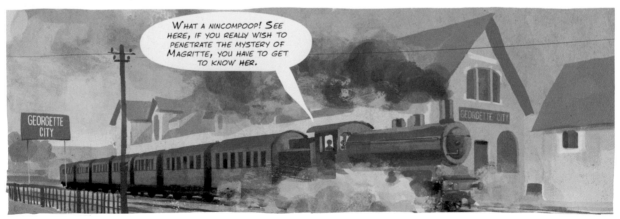

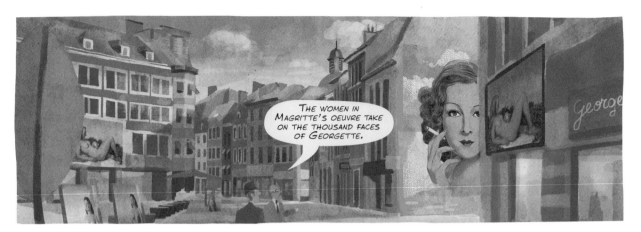

THE WOMEN IN MAGRITTE'S OEUVRE TAKE ON THE THOUSAND FACES OF GEORGETTE.

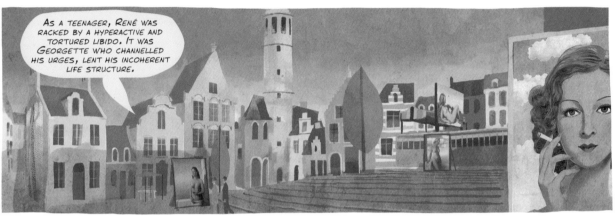

AS A TEENAGER, RENÉ WAS RACKED BY A HYPERACTIVE AND TORTURED LIBIDO. IT WAS GEORGETTE WHO CHANNELLED HIS URGES, LENT HIS INCOHERENT LIFE STRUCTURE.

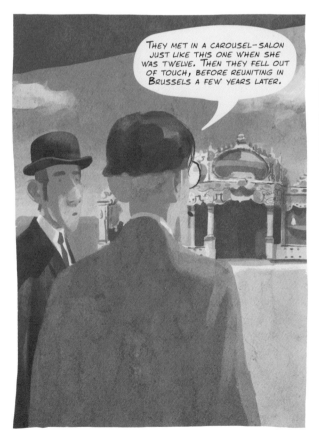

THEY MET IN A CAROUSEL-SALON JUST LIKE THIS ONE WHEN SHE WAS TWELVE. THEN THEY FELL OUT OF TOUCH, BEFORE REUNITING IN BRUSSELS A FEW YEARS LATER.

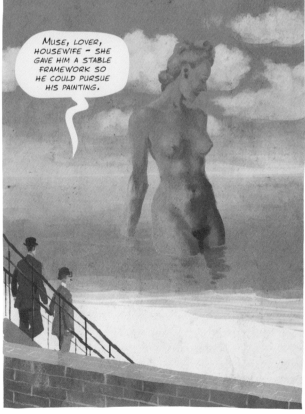

MUSE, LOVER, HOUSEWIFE — SHE GAVE HIM A STABLE FRAMEWORK SO HE COULD PURSUE HIS PAINTING.

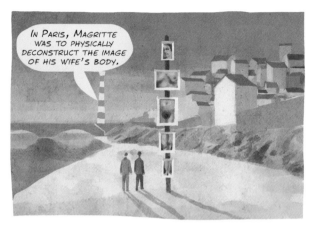

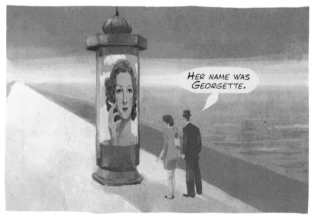

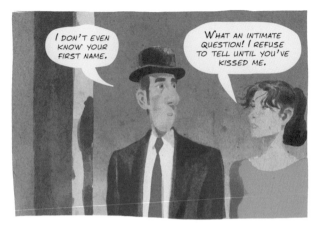

I DON'T EVEN KNOW YOUR FIRST NAME.

WHAT AN INTIMATE QUESTION! I REFUSE TO TELL UNTIL YOU'VE KISSED ME.

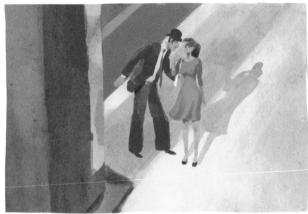

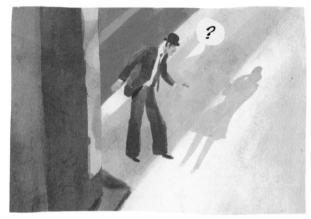

?

MADEMOISELLE?

SAY, YOU'RE THE ONE WHO'S MEANT TO BE UNRAVELLING MAGRITTE'S MYSTERY, NOT ME!

TO SUM UP, THEY BOTH LEFT FOR PARIS, WHERE THEY MET BRETON AND HIS LITTLE GANG OF SURREALISTS.

AND YET THEY SET THEMSELVES UP IN THE SUBURBS! IN PERREUX-SUR-MARNE.

WHY LIVE SO FAR AWAY FROM IT ALL, YOU ASK?

YES, I—

THEY LIKED BEING ON THE FRINGE OF THINGS! IT SUITED HIS TEMPERAMENT AND KEPT HIM FROM FALLING UNDER BRETON'S DESPOTIC RULE.

WOOF!

BEFORE LEAVING, THEY LEARNED THAT GEORGETTE COULD NEVER HAVE CHILDREN, SO THEY ADOPTED A DOG.

THEY'D HAVE DOGS FOR THE REST OF THEIR LIVES. RENÉ EVEN GOT ONE STUFFED.

"I DID SO BECAUSE I LOVED HIM A GREAT DEAL. WHEN GEORGETTE DIES, I'LL HAVE HER STUFFED, TOO." HAHA!

CHARLES, ARE YOU LISTENING?

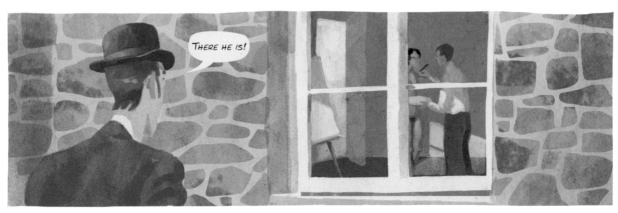

THERE HE IS!

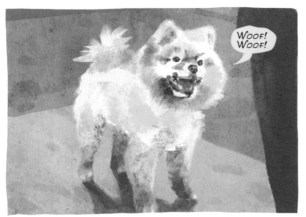

WOOF! WOOF!

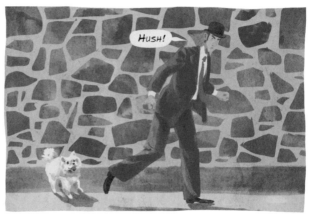

HUSH!

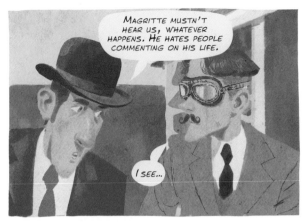

MAGRITTE MUSTN'T HEAR US, WHATEVER HAPPENS. HE HATES PEOPLE COMMENTING ON HIS LIFE.

I SEE...

HE ALSO HATED PAINTING. THE PHYSICAL ACT OF IT, I MEAN. AND YET—

WILL YOU SHUT UP?!

BUT I'M A BIOGRAPHER! I NARRATE!

THIS IS WHERE HE WOULD PERFECT HIS TECHNIQUE AND... AARGHH!

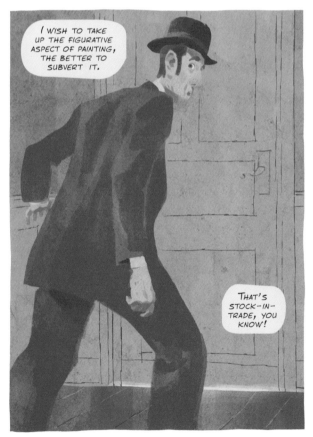

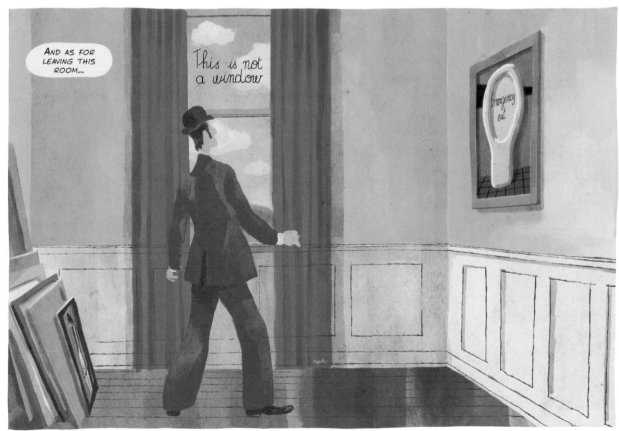

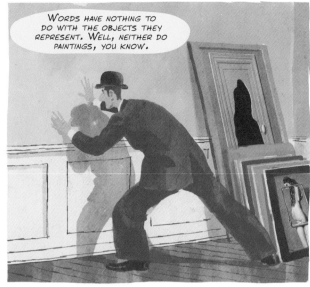

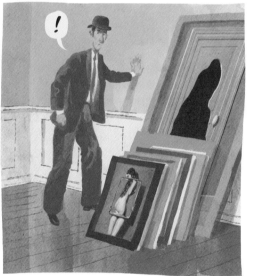

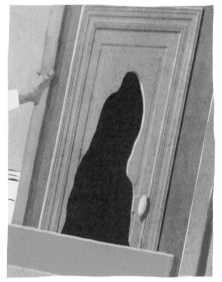

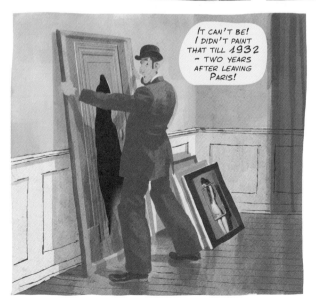

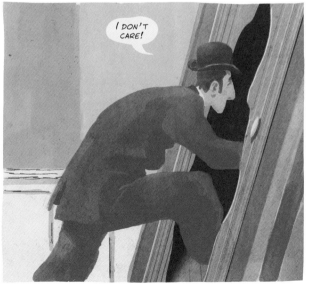

...

YOU'RE IN JETTE, WHERE THE COUPLE MOVED AFTER THEIR PARISIAN ADVENTURE.

?

SO YOU'RE NOT DEAD?

I'M NOT REALLY ALIVE, SO I CAN'T EVER TRULY DIE.

AND SO A LONG, DIFFICULT PERIOD BEGAN. MAGRITTE HADN'T HAD ANY SHOWS IN FRANCE, AND HE WAS OUT OF MONEY. WORRIED AND BROKE, HE LOOKED FOR A JOB IN ADVERTISING.

PITY. I THINK I LIKED YOU BETTER MURDERED.

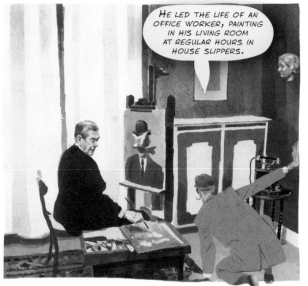

He led the life of an office worker, painting in his living room at regular hours in house slippers.

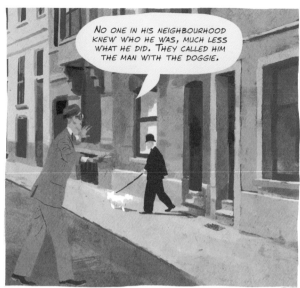

No one in his neighbourhood knew who he was, much less what he did. They called him the man with the doggie.

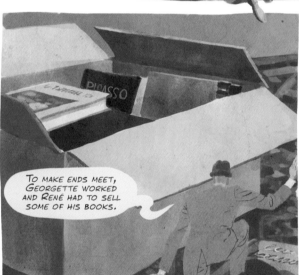

To make ends meet, Georgette worked and René had to sell some of his books.

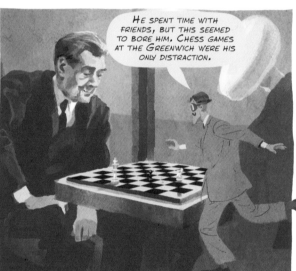

He spent time with friends, but this seemed to bore him. Chess games at the Greenwich were his only distraction.

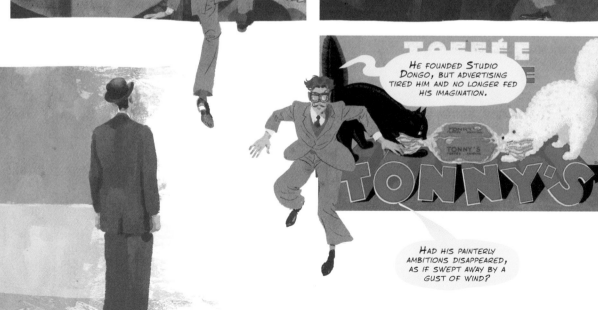

He founded Studio Dongo, but advertising tired him and no longer fed his imagination.

Had his painterly ambitions disappeared, as if swept away by a gust of wind?

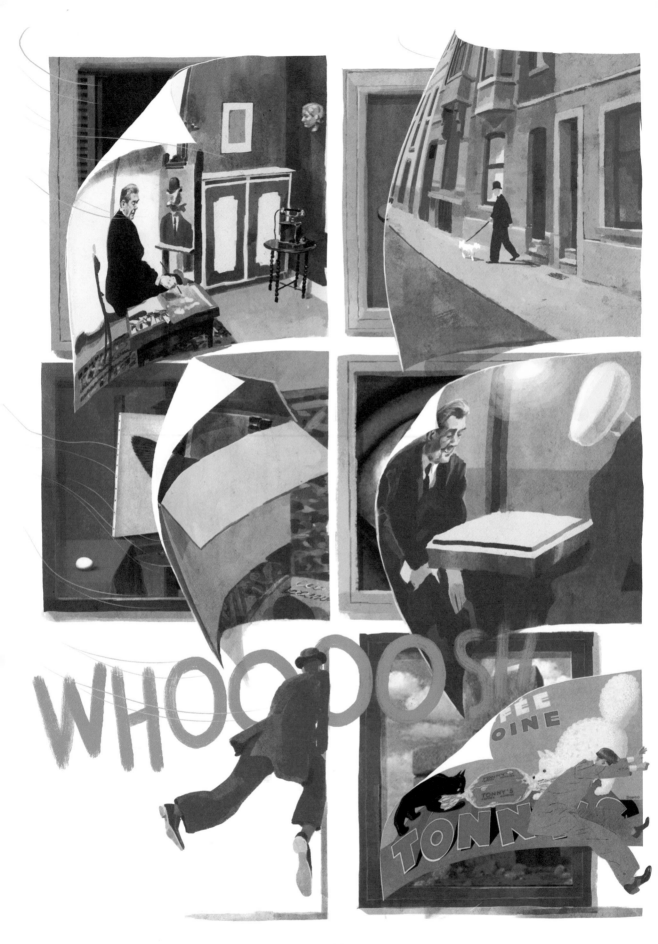

WHOOOOSH

No!

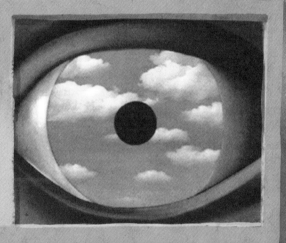

FOR MAGRITTE CONTINUED TO PAINT AND PRODUCE IMAGES MADE FROM IDEAS HE DEVELOPED AND ELABORATED UPON.

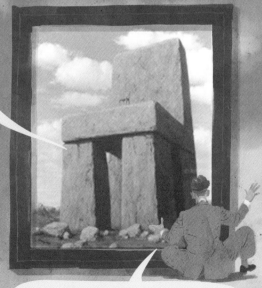

THOUGH HE LED THE LIFE OF A PETTY BOURGEOIS, HIS WORK WAS REVOLUTIONARY.

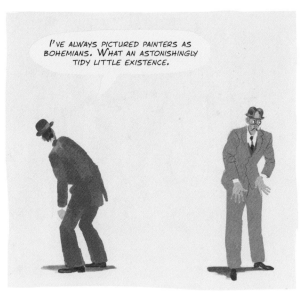

I'VE ALWAYS PICTURED PAINTERS AS BOHEMIANS. WHAT AN ASTONISHINGLY TIDY LITTLE EXISTENCE.

ALL THE MORE SO SINCE HE WASN'T ALWAYS THAT WAY. FAR FROM IT.

LOOK...

THE ARTIST AS A YOUNG MAN AROUND 1919, WHEN HE WAS ATTENDING THE FINE ARTS ACADEMY IN BRUSSELS.

SEE HOW HE PLAYS AT BEING THE BAD BOY — ALMOST DEVILISH? THAT'S NOT THE FACE OF A PETTY BOURGEOIS, IS IT?

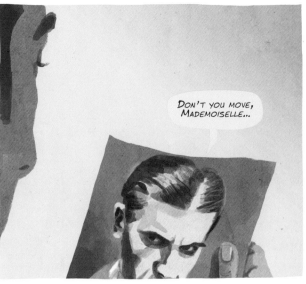

DON'T YOU MOVE, MADEMOISELLE...

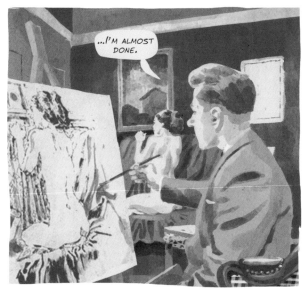

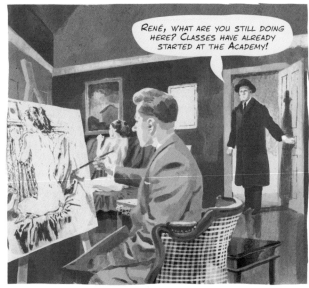

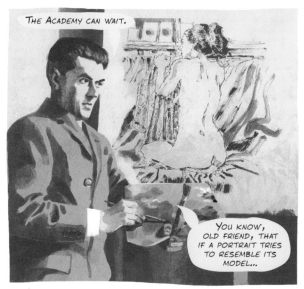

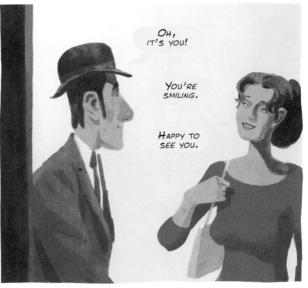

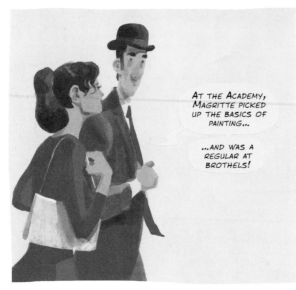

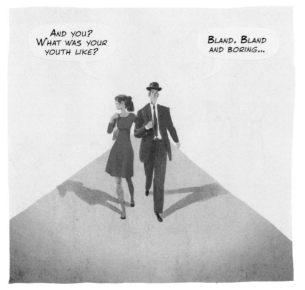

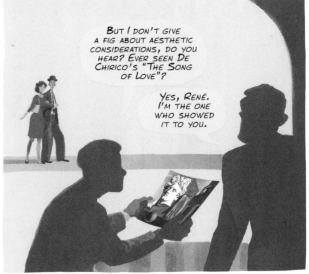

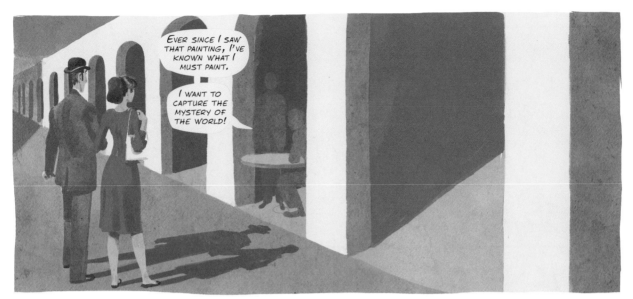

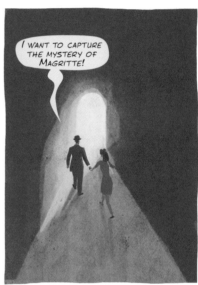

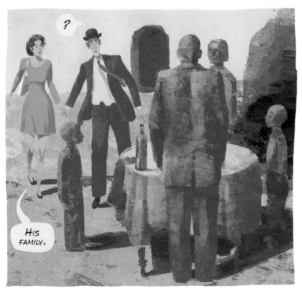

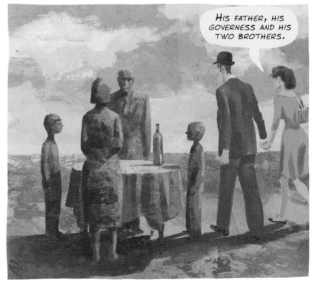

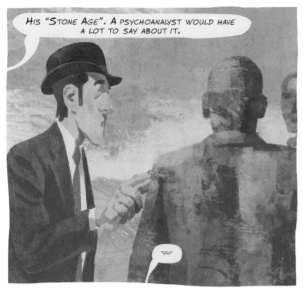

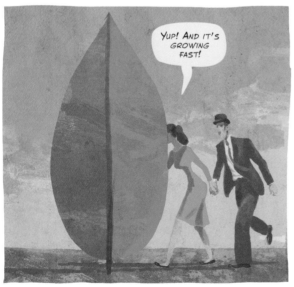

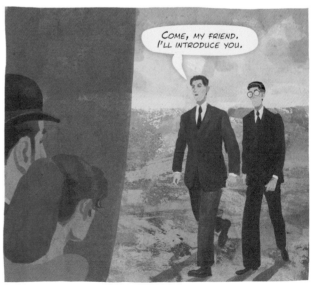

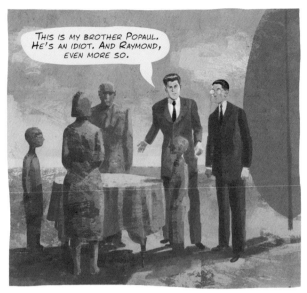

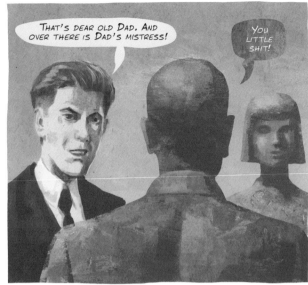

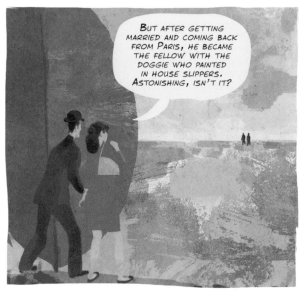

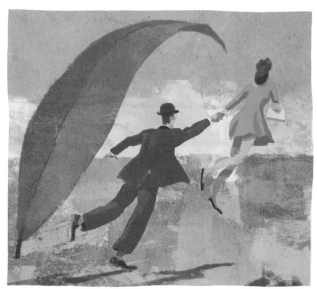

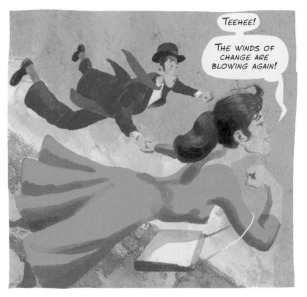

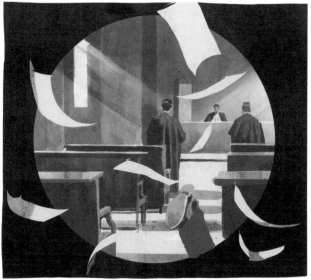

44

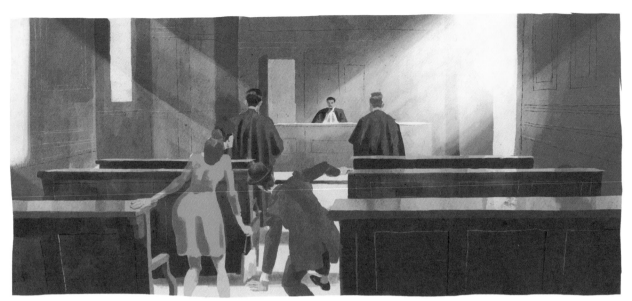

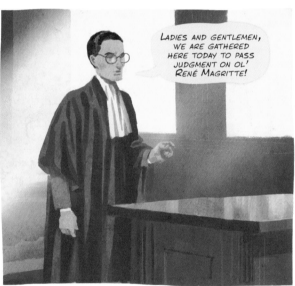

LADIES AND GENTLEMEN, WE ARE GATHERED HERE TODAY TO PASS JUDGMENT ON OL' RENÉ MAGRITTE!

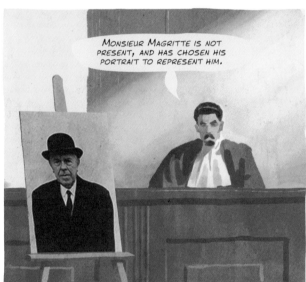

MONSIEUR MAGRITTE IS NOT PRESENT, AND HAS CHOSEN HIS PORTRAIT TO REPRESENT HIM.

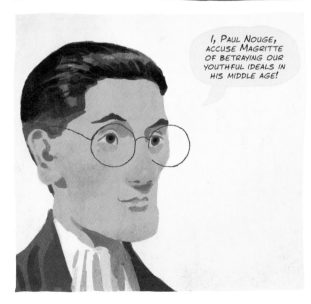

I, PAUL NOUGE, ACCUSE MAGRITTE OF BETRAYING OUR YOUTHFUL IDEALS IN HIS MIDDLE AGE!

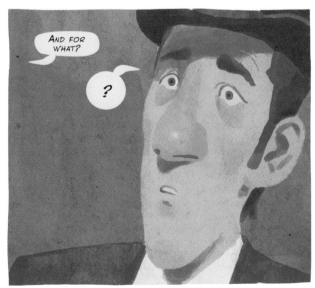

AND FOR WHAT?

?

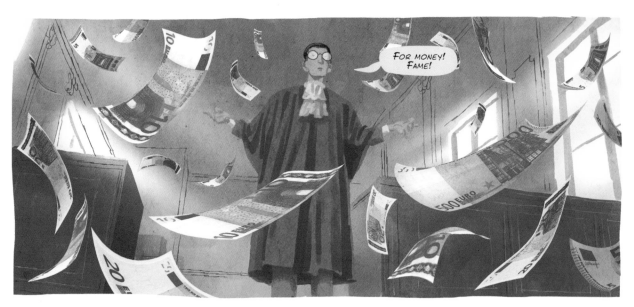

FOR MONEY! FAME!

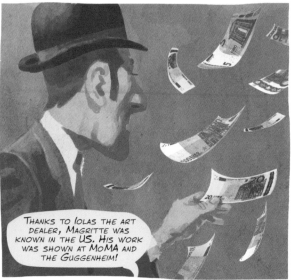

THANKS TO IOLAS THE ART DEALER, MAGRITTE WAS KNOWN IN THE US. HIS WORK WAS SHOWN AT MoMA AND THE GUGGENHEIM!

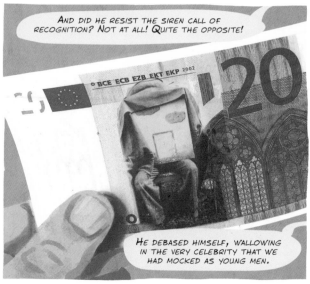

AND DID HE RESIST THE SIREN CALL OF RECOGNITION? NOT AT ALL! QUITE THE OPPOSITE!

HE DEBASED HIMSELF, WALLOWING IN THE VERY CELEBRITY THAT WE HAD MOCKED AS YOUNG MEN.

WHAT BECAME OF THE GREAT REVOLUTIONARY PAINTER?

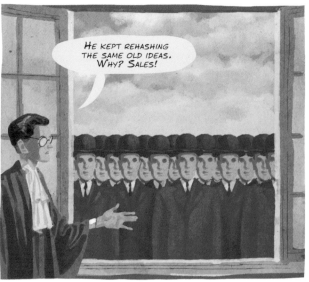

HE KEPT REHASHING THE SAME OLD IDEAS. WHY? SALES!

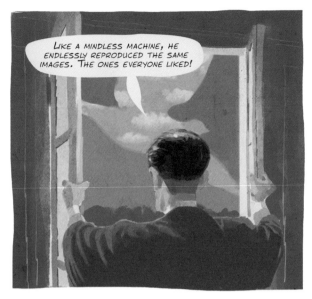

LIKE A MINDLESS MACHINE, HE ENDLESSLY REPRODUCED THE SAME IMAGES. THE ONES EVERYONE LIKED!

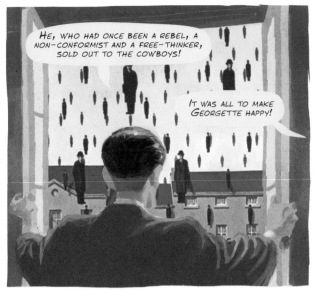

HE, WHO HAD ONCE BEEN A REBEL, A NON-CONFORMIST AND A FREE-THINKER, SOLD OUT TO THE COWBOYS!

IT WAS ALL TO MAKE GEORGETTE HAPPY!

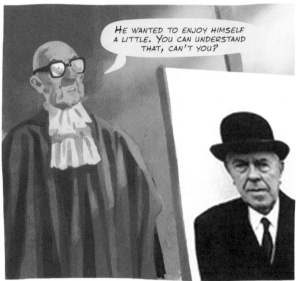

HE WANTED TO ENJOY HIMSELF A LITTLE. YOU CAN UNDERSTAND THAT, CAN'T YOU?

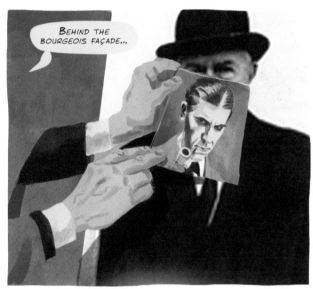

BEHIND THE BOURGEOIS FAÇADE...

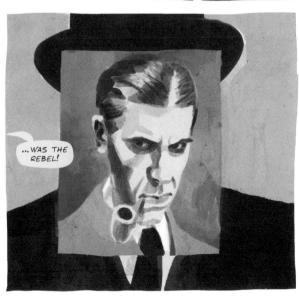

...WAS THE REBEL!

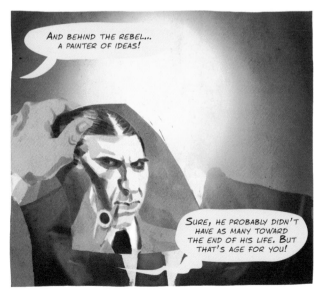

AND BEHIND THE REBEL... A PAINTER OF IDEAS!

SURE, HE PROBABLY DIDN'T HAVE AS MANY TOWARD THE END OF HIS LIFE. BUT THAT'S AGE FOR YOU!

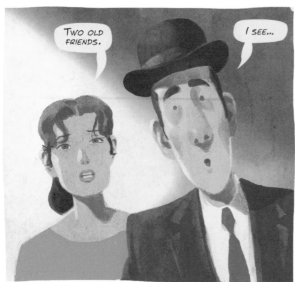

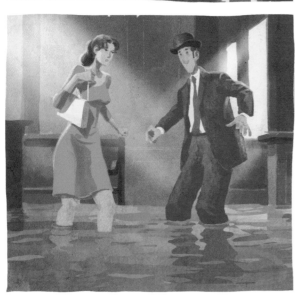

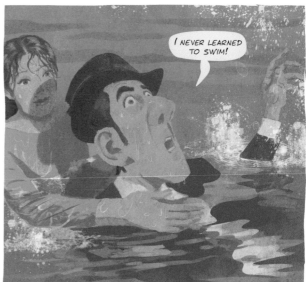

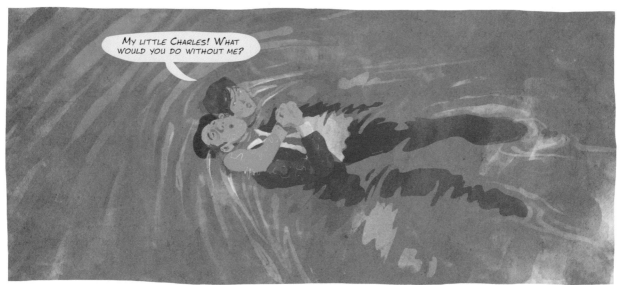

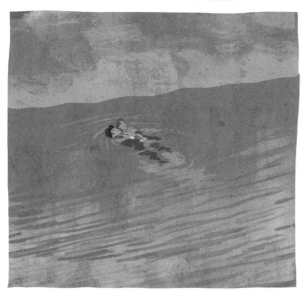

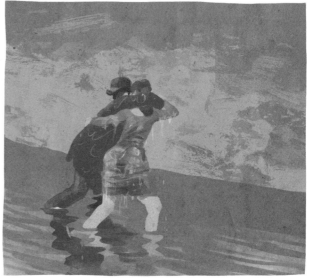

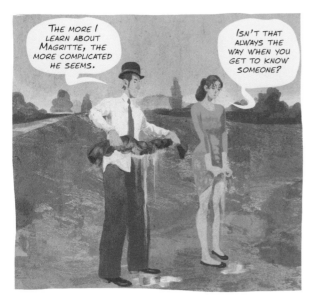

THE MORE I LEARN ABOUT MAGRITTE, THE MORE COMPLICATED HE SEEMS.

ISN'T THAT ALWAYS THE WAY WHEN YOU GET TO KNOW SOMEONE?

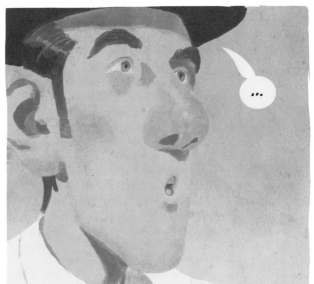

...

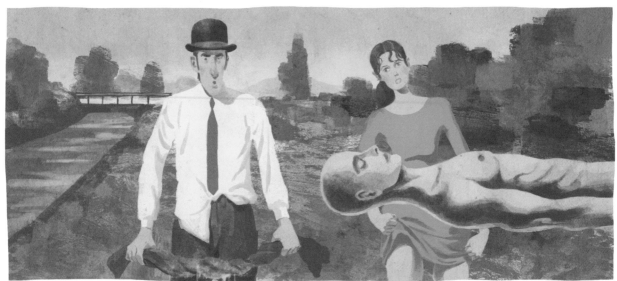

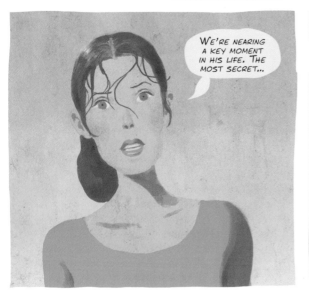

WE'RE NEARING A KEY MOMENT IN HIS LIFE. THE MOST SECRET...

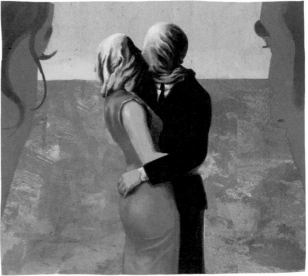

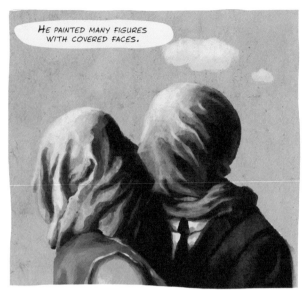

HE PAINTED MANY FIGURES WITH COVERED FACES.

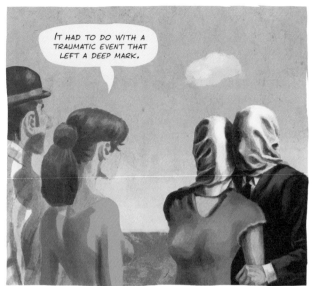

IT HAD TO DO WITH A TRAUMATIC EVENT THAT LEFT A DEEP MARK.

WHICH WAS?

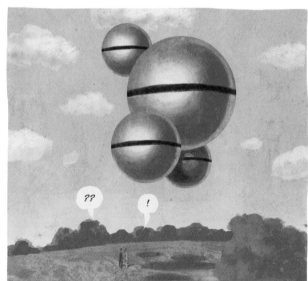

??

!

HE'S CLEARLY NOT PLEASED WE'RE TACKLING THIS PART OF HIS LIFE.

51

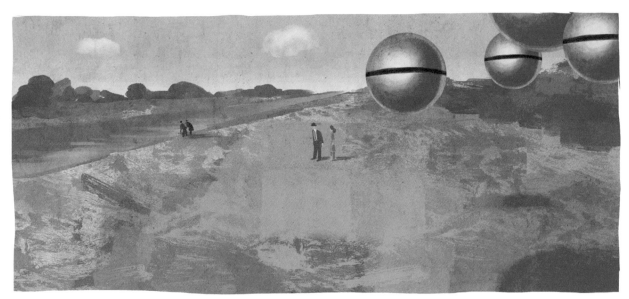

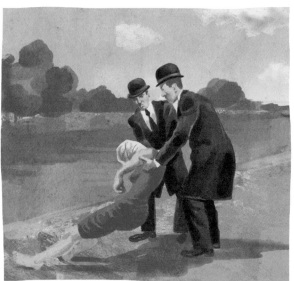

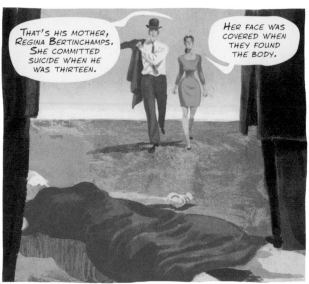

THAT'S HIS MOTHER, REGINA BERTINCHAMPS. SHE COMMITTED SUICIDE WHEN HE WAS THIRTEEN.

HER FACE WAS COVERED WHEN THEY FOUND THE BODY.

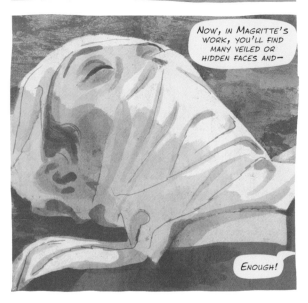

NOW, IN MAGRITTE'S WORK, YOU'LL FIND MANY VEILED OR HIDDEN FACES AND—

ENOUGH!

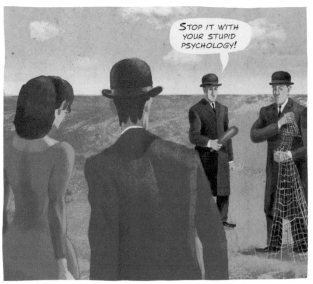

STOP IT WITH YOUR STUPID PSYCHOLOGY!

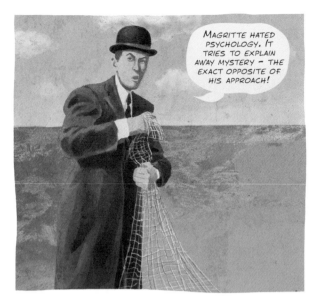

MAGRITTE HATED PSYCHOLOGY. IT TRIES TO EXPLAIN AWAY MYSTERY — THE EXACT OPPOSITE OF HIS APPROACH!

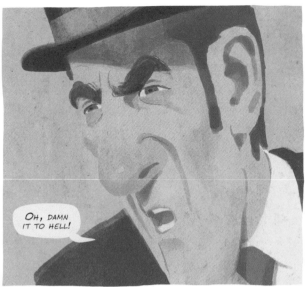

OH, DAMN IT TO HELL!

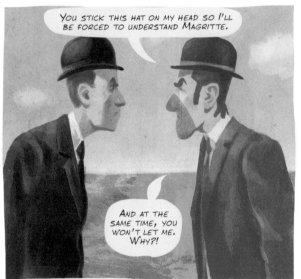

YOU STICK THIS HAT ON MY HEAD SO I'LL BE FORCED TO UNDERSTAND MAGRITTE.

AND AT THE SAME TIME, YOU WON'T LET ME. WHY?!

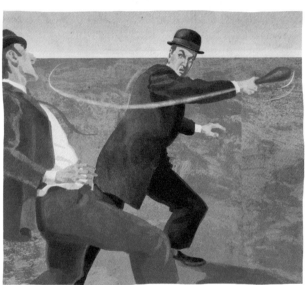

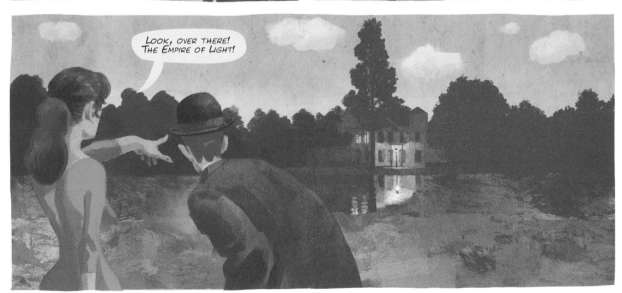

LOOK, OVER THERE! THE EMPIRE OF LIGHT!

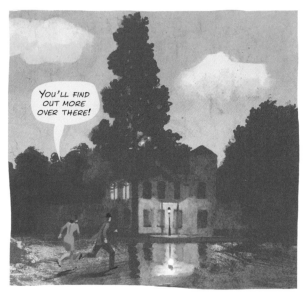

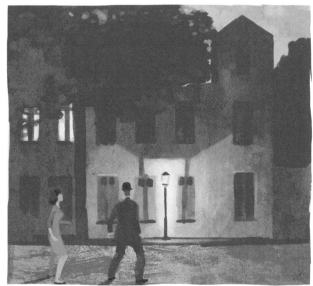

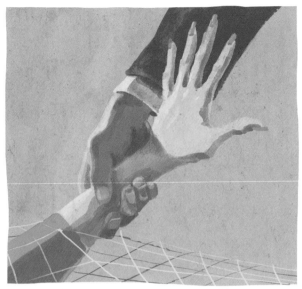

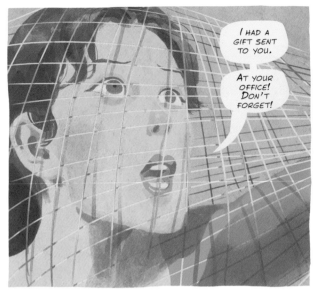

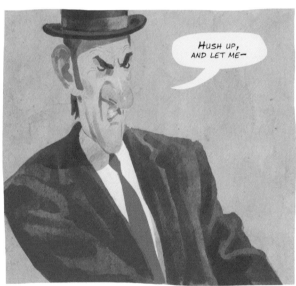

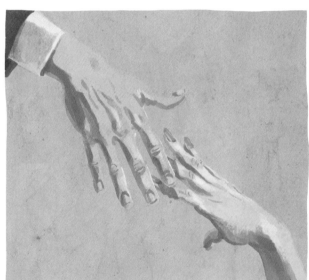

DROWNED!
WHO'D HAVE
THOUGHT?

BELIEVE ME, IF REGINA GOT
DEPRESSED, IT WAS ALL
LEOPOLD'S FAULT!

WHAT WAS THERE TO
DO? OLD MAGRITTE WAS
ALWAYS AT THE BROTHEL.
LEFT HIS WIFE ALL ALONE
WITH THREE CHILDREN.
WILD ANIMALS!

ESPECIALLY THE ELDEST, RENÉ! HE WAS THE WORST OF THE LOT!

THEY SAY HE TIED BELLS TO CATS AND TOSSED BAGS OF POOP FROM BRIDGES!

I EVEN HEARD REGINA CAUGHT HIM ABOUT TO SPIT ON A CROSS. THAT'S PROBABLY WHY SHE TRIED TO DROWN HERSELF!

YES, AND HIS FATHER WAS THE ONE WHO FORCED HIM TO BLASPHEMY!

NO! IT WAS THE CHILD'S OWN IDEA!

I'M TELLING YOU, RENÉ WAS POSSESSED BY A DEMON!

WHAM!

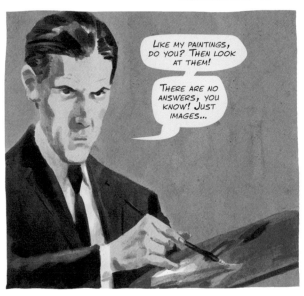

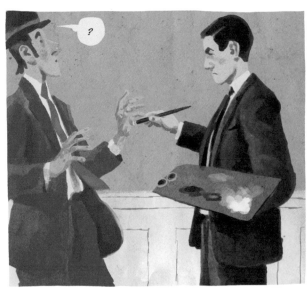

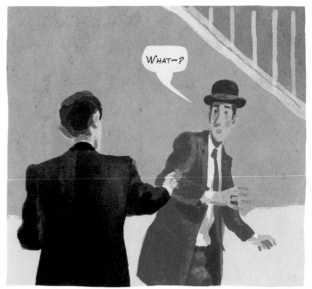

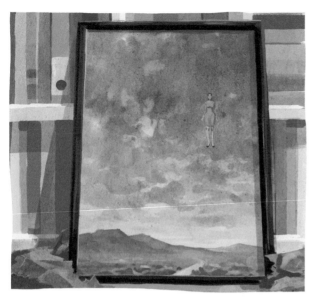

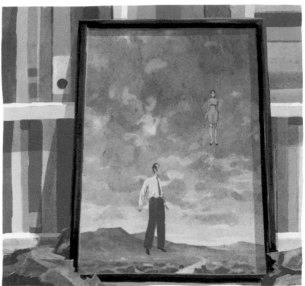

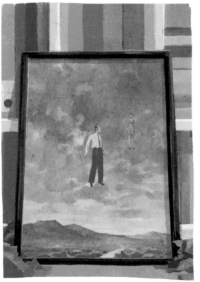

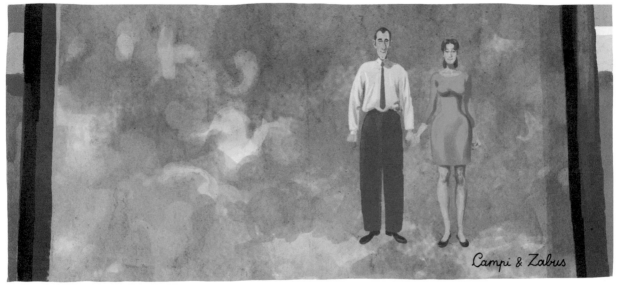

THE END

Oil paintings and watercolours by

Thomas Campi

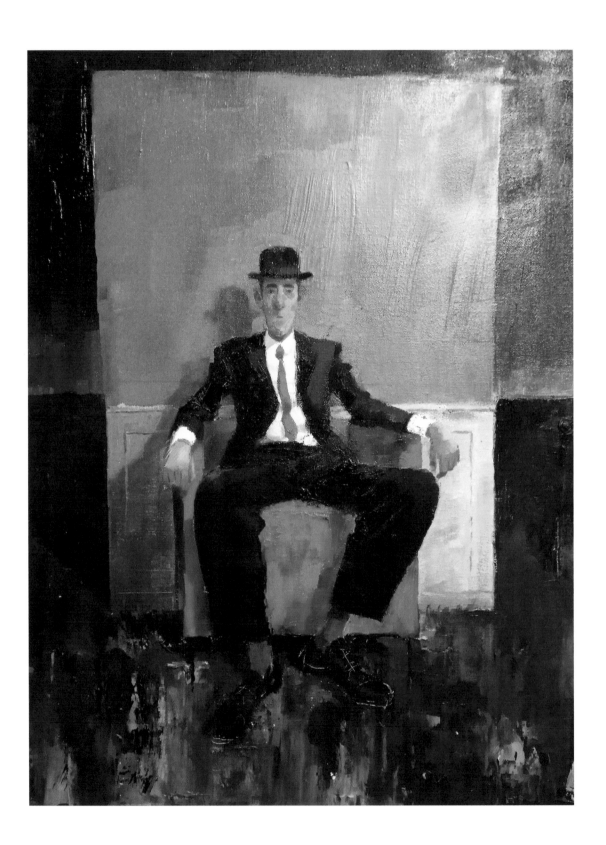

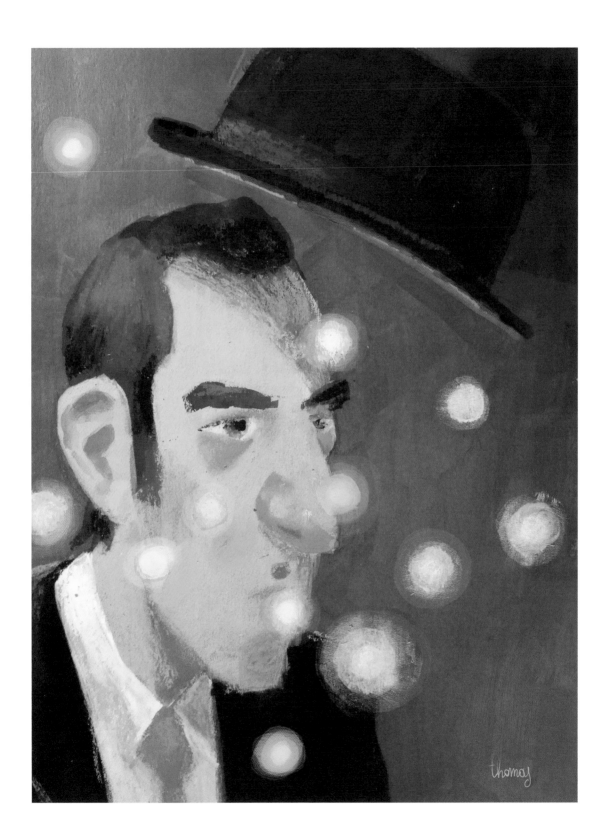

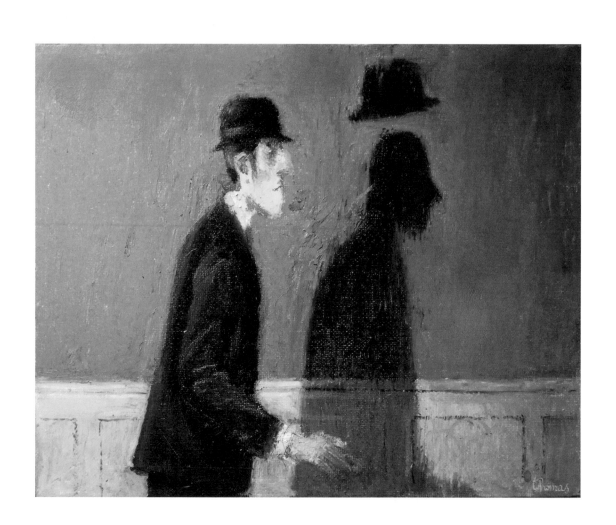

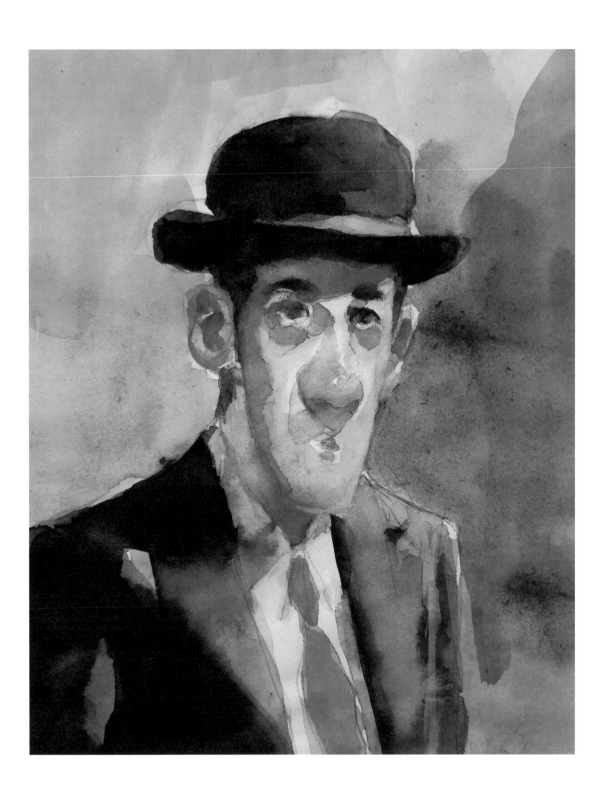

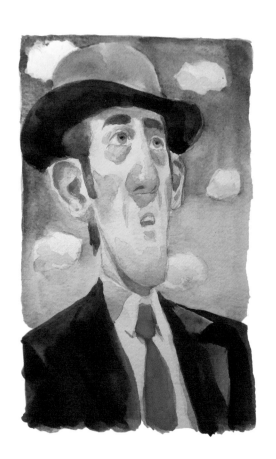
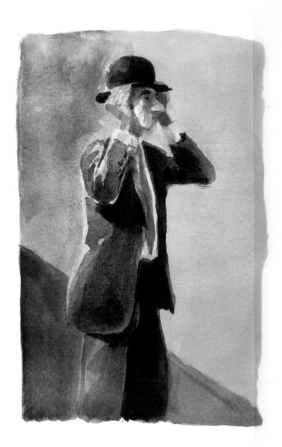
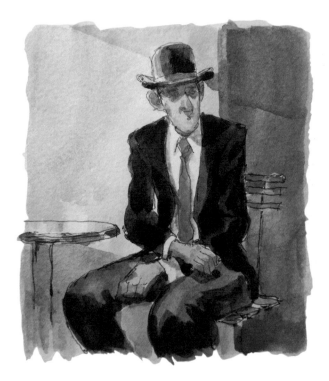

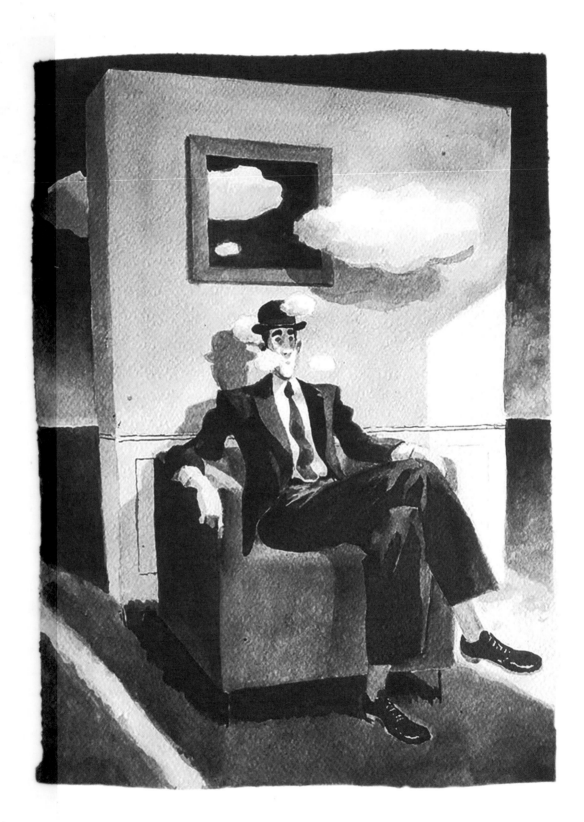

Also available in the **ART MASTERS** series:

VINCENT
by Barbara Stok

ISBN 978-1-906838-79-9
Paperback, 144 pages
RRP: UK £12.99
US $19.95 CAN $21.95

MUNCH
by Steffen Kverneland

ISBN 978-1-910593-12-7
Paperback, 280 pages
RRP: UK £15.99
US $24.95 CAN $29.95

GAUGUIN
by Fabrizio Dori

ISBN 978-1-910593-27-1
Paperback, 144 pages
RRP: UK £12.99
US $19.95 CAN $23.95

PABLO
J. Birmant and C. Oubrerie

ISBN 978-1-906838-94-2
Paperback, 344 pages
RRP: UK £16.99
US $27.50 CAN $33.50

DALÍ
by Baudoin

ISBN 978-1-910593-15-8
Paperback, 160 pages
RRP: UK £12.99
US $19.95 CAN $23.95

Available in all good bookshops